Botanical
Inspirations

By Lynn Araujo

Copyright © 2017 U.S. Games Systems, Inc.

All rights reserved. The illustrations, cover design, and contents are protected by copyright. No part of this booklet may be reproduced in any form without permission in writing from the publisher, except by a reviewer who wishes to quote brief passages in connection with a review written for inclusion in a magazine, newspaper or website.

Designed by Nora Paskaleva

10 9 8 7 6

Made in China

Published by
U.S. GAMES SYSTEMS, INC.
179 Ludlow Street • Stamford, CT 06902 USA
www.usgamesinc.com

INTRODUCTION

This Botanical Inspirations deck arose from a personal passion for all things floral, especially antique botanical prints. In addition to being an avid gardener, for years I have collected vintage gardening books, charming botanical ephemera including vintage seed packet art and tobacco insert cards, and of course illustrated volumes, old and new, about flower lore and the Secret Language of Flowers. In researching this project it's been fascinating to discover the varied meanings flowers have in different cultures.

This deck consists of 44 cards, each presenting a flower with its common name and Latin name or alternative name. Underneath the images on the cards are quotations and keywords or phrases describing the symbolism of the flower. In Victorian England, and in other cultures, flowers were used to convey specific meanings and messages,

especially in the coy rituals of courtship. In the Secret Language of Flowers anemones, for example, symbolized anticipation and dahlias represented dignity. The garden heliotrope was given as a pledge of eternal devotion. Included in this set is a fold-out reference guide to the Secret Language of Flowers.

The accompanying guidebook presents charming narrative vignettes about each flower and the special symbolism culled from history, literature, lore and legend, religion and spiritual practices, and of course the Secret Language of Flowers. From the demure violet to the noble magnolia, all flowers have stories to tell and lessons to share. Flowers can be gentle reminders to keep our eyes and our hearts open. Each lovely flower included in this deck also brings a message of wisdom and insight. It is hoped that this deck will be enjoyed by gardeners and all those who appreciate flowers for their beauty and their special ability to inspire and uplift us all.

THE CARDS

AMARYLLIS
Amaryllis

Symbolism: Determination & Creative Achievement

"You can't use up creativity. The more you use, the more you have."

— Maya Angelou

According to legend, Amaryllis was a love-struck maiden who had to get creative in order to gain the affection of the handsome shepherd who was only interested in his flowers. In desperation, she pierced her own heart, leaving a path of blood droplets to his front door. After thirty days, the droplets turned to stunning scarlet flowers. The shepherd was so taken with the flowers he fell in love with Amaryllis and her heart was healed. The amaryllis has come to be associated with pastoral poetry. To the Victorians, the winter-blooming amaryllis was a symbol of determination that was often given to artists to inspire their creativity.

Inspirational Message: When the Amaryllis appears, it means your muses have blessed you with their inspiration. Fulfill your creative destiny and your achievements will be recognized and rewarded.

ANEMONE
Windflower

Symbolism: Anticipation

"I felt like an arrow, pulled back and ready to be launched into something big."

— A.B. Shepherd

This intricate and aptly named flower, meaning "daughter of the wind", has inspired poets and artists throughout time. The anemone flower closes up its petals at night and when rain is on the way. Perhaps that is why the Victorians associated the flower with both fading hope and expectation. Yet like the gentle breeze it is named after, the eagerly awaited bloom returns again. The lovely anemone is one of the first signs of spring, so it aptly relates to anticipation.

Inspirational Message: When others begin to lose hope, you sense bright possibilities on the horizon. Like the "daughter of the wind" you eagerly anticipate the changes and challenges of each new dawn.

APPLE BLOSSOMS
Malus domestica

Symbolism: Choices, Knowledge & Illumination

*"White are the flowers of apple tree,
that brings us fruits of fertility."*

— Unknown

The apple itself is an eternal symbol of abundance, prosperity and generosity. To the ancient Celts, the apple blossom was a sign of fertility and was offered as a gift of love. In the Language of Flowers (which is very much the language of lovers), the apple blossom designated preference; the lady's choice of one suitor over another. The apple tree and its blossoms also represent gateways to other worlds of knowledge, illumination and magic. It opens up our awareness of always having choices.

Inspirational Message: The apple blossom brings the gift of illumination. Once you have opened your eyes and your heart to the real abundance all around, you free yourself from the illusion that you are lacking for anything.

ASTERS
Callistephus

Symbolism: Elegance & Patience

"Nature does not hurry, yet everything is accomplished."

— Lao Tzu

Meaning 'stars', asters were considered sacred flowers to ancient Romans and Greeks. According to myth, when Virgo scattered stardust on the earth, the fields became filled with countless blooming asters. From this story, asters have come to symbolize wonderful surprises. Throughout Europe, the aster plant was believed to possess magical powers, capable of driving away serpents. In the Victorian Language of Flowers, asters are a talisman of love and a symbol of elegance. The star-shaped asters are a sign that those who have patiently waited for love to bloom have been rewarded.

Inspirational Message: Develop patience by staying focused on the present moment, and having faith that everything will happen at the right time. Let life surprise you!

BELLFLOWER
Campanula

Symbolism: Gratitude

"Gratitude makes sense of our past, brings peace for today, and creates a vision for tomorrow."

— Melody Beattie

There are all kinds of enchanting stories associated with the bellflower. In ancient mythology, Venus owned a magic looking-glass with the power to transform anything ordinary into something beautiful. When Cupid accidentally broke the mirror each broken shard turned into a lovely bellflower. Sweet little bellflowers are also believed by some to be gifts of gratitude left by fairies.

Inspirational Message: You find the goodness in small things that others might miss. By looking at the bright side, you are cultivating true gratitude.

CAMELLIA
Camellia blanc

Symbolism: Destiny

"It is not in the stars to hold our destiny but in ourselves."

— William Shakespeare

Throughout Asia, the camellia is revered as a sacred flower. It is the national flower of China, where it symbolizes daughters and sons. To the Japanese, it is an emblem of the divine. In Korea it is used in wedding ceremonies to represent longevity. Camellias were imported from Asia to Victorian England for winter balls and they had a special meaning for lovers. The gift of a white camellia sent the message that the sender and the recipient were destined to be together.

Inspirational Message: When you look all around you see signs that your fate is unfolding as it should. When you direct your gaze within, seeing what is in your own heart, you discover your true destiny.

CLEMATIS
Clematis alpina

Symbolism: Intelligence & Mental Beauty

"Wisdom is the abstract of the past, but beauty is the promise of the future."

— Oliver Wendell Holmes, Sr.

The clematis is known for its climbing habit, gently making its way up over arbors and trellises, lending a lofty beauty to the garden. It was christened the "Virgin's Bower" as a tribute to Queen Elizabeth I, who was taken with its enchanting fragrance. The flower came to be associated with her intelligence and mental beauty. Later, as the popularity of the clematis spread, the flower also came to emblemize worldliness. It was also called "Traveler's Joy" since the spreading vine provided shade on porches and inn entranceways.

Inspirational Message: Keep your feet firmly planted on the ground with the foundation of knowledge. Expand your mind with new experiences and your spirits will soar to new heights.

COREOPSIS
Tickseed

Symbolism: Always Joyful

"Write it on your heart that every day is the best day of the year."

— Ralph Waldo Emerson

Coreopsis takes its name from Kore in Greek mythology. While picking wildflowers in the meadow, Kore (also known as Persephone) was abducted by Hades and taken to the underworld. In despair, Demeter struck a bargain that would allow her daughter to return each spring after four months of barren winter. For the eight months Kore is in the land of the living, there is continuous revelry and the world blooms with color and joy. The coreopsis plant was also sacred to the Cherokees and Apaches, who used the plant for spring rituals and blessings.

Inspirational Message: You've learned to weather the cycles of life. After dark periods, the sun always returns and your spirit is renewed. If you look, you'll find a reason to celebrate each day with an attitude of *joie de vivre*.

CROCUS
Crocus sativus

Symbolism: Cheerfulness

"It is spring again. The earth is like a child that knows poems by heart."

— Rainer Maria Rilke

The crocus gets its name from a legendary young shepherd whose love and devotion for the young nymph Smilax was so noble and pure it impressed the gods who gave him the gift of immortality by turning him into a flower. As the colorful petals of the crocus push up through the snow, the petite flower brings a smile to everyone who witnesses this mini miracle. The crocus is a powerful symbol of youthful mirth and good cheer. It is a reminder to never take life too seriously, to approach everything with the optimism and innocence of a child.

Inspirational Message: Even when you are feeling fragile and delicate, there is a core of cheerfulness within you that always seems to find its way to the surface.

DAFFODIL
Narcissus

Symbolism: Rebirth & New Beginnings

"New beginnings are often disguised as painful endings."

— Lao Tzu

Though in mythology Narcissus is associated with self-love, in the Victorian Language of Flowers the daffodil symbolizes 'high regard' and 'chivalry'. The sweeping drama of a sunny meadow filled with daffodils inspired Wordsworth's most famous poem. To many, the daffodil is associated with Easter, the Resurrection, and the Vernal Equinox. Among the first cheerful flowers to announce the start of springtime after the long winter, the daffodil is a sign of rebirth and new beginnings.

Inspirational Message: Now is the time to step into the light, shed your old ways and begin a new phase of your life. Hold yourself in high regard and others will too.

DAHLIA
Dahlia hortensis

Symbolism: Dignity

*"A wise man has dignity without pride;
a fool has pride without dignity."*

— Confucius

Dahlias originated in Mexico and were brought to Europe in the 16th century by Spanish explorers. The Empress Josephine imported them for her own garden at the Château de Malmaison in France. The dahlias were so rare and precious (worth more than diamonds) that Josephine tended to them personally. The colorful blooms put on their elegant show after most other flowers were done for the season. Dahlias epitomize grace and dignity and came to be called "the queen of the autumn garden".

Inspirational Message: It's easy enough to simply attract momentary attention. But to earn the ongoing respect of others requires frequent displays of dignity.

FALSE INDIGO
Baptisia australis

Symbolism: Immersion & Intuition

"When you reach the end of what you should know, you will be at the beginning of what you should sense."

— Kahlil Gibran

The common name of this plant, false indigo, derives from the fact that the blue dye made from this flower was used as a substitute for indigo in the New World. Though the Latin name *baptisia* means immersion and actually relates to the dying process, through folklore the plant has come to have an association with spiritual baptism. The strikingly tall spires of this garden plant are covered with deep, indigo blue flowers that also have a mystical correlation with the third eye chakra, which opens up perception, insight and intuition.

Inspirational Message: To experience things at a deeper level, look beyond what your five senses reveal. Immerse yourself in your own inner knowing. Trust your intuition to reveal the truths that will guide you to a fully-realized life.

FORGET-ME-NOTS
Myosotis scorpioides

Symbolism: Eternal Memories

"The best things in life are the people you've loved, the places you've seen, and the memories you've made along the way."

— Unknown

Of the many legends surrounding the forget-me-not flower, the most poignant is the story of the medieval knight who fell into the river while picking flowers with his lady love. As his heavy armor dragged him under, he called out to her "Forget me not!" Putting these dainty blue flowers under your pillow is said to be a way for recovering lost memories, especially of loved ones. They are a sweet reminder to remember the people who are gone.

Inspirational Message: Like the forget-me-not flower, memories can crop up in unexpected places. Make room in your heart for the tender memories of lost loved ones, right alongside the happy memories you cherish.

GARDEN HELIOTROPE
Heliotropium arborescens

Symbolism: Devotion & Dreams Fulfilled

"The future belongs to those who believe in the beauty of their dreams."

— Eleanor Roosevelt

The Greek word heliotrope means "turns toward the sun". In ancient Greek mythology, the maiden Clytia was so enamored of Apollo she would gaze at him each day as he passed in his chariot pursuing another love. The gods took such pity on the forlorn Clytia that they turned her into a fragrant flower, whose face is forever gazing upward. If you observe heliotropes you will notice the flowers and foliage are turned toward the sun. The heliotrope has become a symbol of eternal devotion and dreams fulfilled.

Inspirational Message: Find your one true love and only then give your heart fully. In the meantime, cherish yourself and devote yourself to your passions and dreams.

GERBERA DAISY
Gerbera

Symbolism: Purity, Cheerfulness & Innocence

"The present moment is filled with joy and happiness. If you are attentive you will see it."

— Thich Nhat Hanh

European miners first discovered gerbera daisies in South Africa in 1884. When botanists started breeding programs during the 19th century, gerbera daisies became some of the most cherished flowers in the world because of the rainbow of vibrant color variations that became available. Egyptians felt the gerbera held the meaning of closeness to nature and devotion to the sun. The Celts believed gerbera daisies had the power to remove sorrow and stress. Gerbera daisies of all colors, especially yellow and pink, emanate light-heartedness and happiness. The white daisy holds the special meaning of purity and the innocent joy of childhood.

Inspirational Message: The child finds innocent pleasure in picking a daisy and discovers joy when she gives that flower to someone special. When you spread joy around, you will find that you have more than you started with.

GLADIOLA
Gladiolus

Symbolism: Strength of Character & Moral Integrity

"Character cannot be developed in ease and quiet. Only through experiences of trial and suffering can the soul be

strengthened, vision cleared, ambition inspired and success achieved."

— Helen Keller

The most striking feature of the gladiola is its tall, sword-like spire pointing toward the heavens. When the distinctive plants were brought to Europe from Africa and Asia they were named for gladiators, ancient Roman soldiers who lived and died by the sword. Because of this association, in the Victorian Language of Flowers the gladiola symbolized the romantic gesture of figuratively "piercing one's heart" for the sake of love. The elegant flowers also project the meaning of moral integrity and strength of character.

Inspirational Message: Doing the right thing isn't always easy. But the strength you summon now builds upon your core of integrity that will later serve your highest purpose in all that you do.

GLOXINIA
Gloxinia perennis

Symbolism: Love at First Sight & Proud Spirit

"When I saw you I fell in love, and you smiled because you knew."

— William Shakespeare

The aromatic gloxinia flower was first identified by Gloxin, an 18th century German botanist in the jungles of Brazil and Central America. To the discoverers who came upon this showy flower, and to the Victorians who immediately became enamored of it, the gloxinia signified "love at first sight". When closed, the flower has a trumpet-like shape; when open, the five velvety petals form a bell. The tropical plant is drawn to warm, bright light. The gloxinia has also had a shamanic significance and embodies the 'proud spirit'.

Inspirational Message: There are rare moments in life when you meet someone and you know in an instant that this person will be important to you for a long time. People come into our lives to teach us the lessons we are ready to learn. *"Some stay for a while, leave footprints on our hearts, and we are never, ever the same."* — Flavia Weedn

HIBISCUS
Hibiscus rosa sinensis

Symbolism: Beauty & Happiness

"A thing of beauty is a joy forever."

— John Keats

The hibiscus is known as the "Queen of the tropical islands". Giving a woman a hibiscus is considered a flattering way to acknowledge her beauty. If a woman wears the flower behind her left ear, that means she is looking for love. If she wears it behind her right ear, it means she is spoken for. In the Victorian Language of Flowers, the hibiscus means 'delicate beauty'. Today, it is an outward expression of joy.

Inspirational Message: Celebrate the beauty within you and all around you. You will attract happiness into your life when your message to the universe is clear. Seek joy.

HONEYSUCKLE
Woodbine

Symbolism: Domestic Happiness & Devoted Affection

"I will wind thee in my arms. So doth the woodbine, the honeysuckle, gently entwist."

— William Shakespeare

The honeysuckle is named for its heavenly sweet perfume. Also known as woodbine, this flowering vine's tenacity and clinging nature give it the symbolic meaning of 'devoted affection'. In the Language of Flowers, many plants have both a positive and a negative meaning. However, the honeysuckle's associations are all positive: sweetness, happiness, bonds of love, resilience and affection. Once established, the honeysuckle can be relied upon to remain a constant fixture in the garden. It is believed that if allowed to grow up around the entranceway, the honeysuckle will protect the home and its inhabitants. Thus, it has also come to symbolize domestic happiness.

Inspirational Message: Bring your best self to the relationships that are the closest to your heart. Even the well-established bonds of affection still need mindful tending to thrive. Thoughtfulness, support and kind words go a long way toward maintaining a happy home life.

HYACINTH
Hyacinthus orientalis

Symbolism: Playfulness

"Play is the royal road to childhood happiness and adult brilliance."

— Joseph Chilton Pearce

The hyacinth received its name and its meaning related to play from the Greek youth, Hyacinthus, the childhood companion of Apollo. According to myth, Apollo was showing Hyacinthus how to throw the discus. The wind god Zephyrus grew jealous and blew the discus toward Hyacinthus, hitting him in the head and killing him. From his blood grew the red hyacinth. In spite of the sad tale, to the Victorians the flower had a positive and light-hearted meaning. Pink hyacinths are especially associated with youthful play in early springtime.

Inspirational Message: Take time each day for light-hearted fun. Take a break from work and simply get up and move. Go outside barefoot and feel the grass between your toes. Twirl around and let the wind take your troubles away. A playful attitude will infuse everything you do with more energy.

HYDRANGEA
Hydrangea macrophylla

Symbolism: Thankfulness for Understanding

"Before we can forgive one another, we have to understand one another."

— Emma Goldman

Though the Victorians felt the showy hydrangea plant to be a symbol of boastful vanity, in Japan, where the flower originated, the lovely hydrangea was associated with asking for understanding for one's mistakes and being thankful for forgiveness. Today, the profuse blossoms are symbolic of heartfelt emotions, particularly gratitude. When the blooms are cut and shared, more grow in their place.

Inspirational Message: When you forgive others, you release yourself from unnecessary suffering and make space for healing. Grant yourself the benefit of the same compassion and understanding you offer to other people.

IRIS
Iris germanica

Symbolism: Rainbows & Messages

*"When it rains, look for rainbows.
When it's dark, look for stars."*

— Unknown

The stately flower borrowed its name from Iris, the Greek goddess of the rainbow. It was her duty to transport the souls of departed women to the Elysian Fields. In the Language of Flowers, Iris came to mean 'messages' since its namesake carried messages along the rainbow between the realms of the mortals and the gods. The majestic iris flower inspired the French *fleur de lis* motif, with the three petals symbolizing faith, wisdom and valor.

Inspirational Message: Keep your eyes open to the wisdom of the universe and you will receive clear signs and messages that guide you on your path.

LILAC
Syringa

Symbolism: First Emotions of Love

"Love is the magician that pulls man out of his own hat."

— Ben Hecht

Lilacs are among the most sweetly fragranced flowers to be found anywhere. Their brief but captivating beauty is celebrated in the poetry of Walt Whitman and Robert Burns, among others. In the Language of Flowers, purple lilac blossoms represent the first emotions of new love and the white lilac is emblematic of youthful innocence. Lilacs owe their botanical name to the beautiful Greek nymph Syringa who turned herself into a fragrant bush in order to escape the unwanted advances of Pan, the god of the forest and the fields. In Russian folklore, the lilac bush is believed to bring wisdom to newborn babies.

Inspirational Message: Like the lilacs' fleeting beauty, you cannot hold forever that elusive feeling of falling in love for the first time. Don't get caught up in trying to chase that feeling down. Just nurture love and you will see it blossom and grow.

LILY
Lilium

Symbolism: Majesty & Virtue

"The lily is the emblem rare, of many virtues good and rare."

— Unknown

Lilies are among the most exalted flowers in the world, held in high regard and long considered sacred by numerous ancient civilizations. In Christian lore, the lily is said to have sprang from the repentant tears of Eve after her expulsion from the Garden of Eden. The lily was also regarded as the symbol of the Virgin Mary's purity. In pagan and Christian cultures and throughout Victorian times, the lily was a sign of chastity before marriage, and of fertility afterwards.

Inspirational Message: It's not about what you say or what you feel that matters. It's not enough to *talk* about what's virtuous. In the end it's what you actually *do* that counts. Let your actions come from virtue.

MAGNOLIA
Magnolia

Symbolism: Nobility & Self-esteem

"There is nothing noble in being superior to your fellow men. True nobility lies in being superior to your former self."

— Ernest Hemingway

According to fossil records, the magnolia tree was the first flowering plant to have evolved on earth. In Ancient China and throughout South America the magnolia flower has held special significance to brides, symbolizing nobility and stability. In pagan rites, the luminous white magnolia evokes the lunar goddesses. Since Victorian times the magnificent magnolia flower has come to emblemize dignity, self-esteem, poise and nobility.

Inspirational Message: Nobility is not just something you are born to, or a quality to wish for. It is an evolving process requiring lifelong commitment. To develop self-esteem, commit estimable acts. To build good character, act with nobility of purpose.

MORNING GLORY
Ipomoea

Symbolism: Affection & Determination

"The morning glory, which blooms for a day, differs not at heart from the giant pine that lives for a thousand years."

— Alan Watts

Each flower on the meandering morning glory vine blooms only for a single day. As dusk darkens the sky, the flowers all curl up for the night. The very next morning brings fresh growth and the promise of yet more glorious flowers upon each vine. In the Victorian Language of Flowers, the morning glory with its tenacious tendrils was associated with love and affection. In Chinese lore, the morning glory symbolized the determination of two legendary lovers who resolved to meet even after their parents separated them with a wide river.

Inspirational Message: When life becomes challenging, remember the morning glory, for which nothing is an obstacle. A fence or wall simply gives the tender but determined vine a new place to grow and another reason to climb higher toward the sun.

NASTURTIUM
Tropaeolum

Symbolism: Victory & Conquest

"He who controls others may be powerful, but he who has mastered himself is mightier still."

— Lao Tzu

The entire nasturtium plant is edible including its flowers, leaves and seeds. The name translates from the Latin phrase 'nose-twister' a reference to the plants' pungent, peppery taste. There are several stories that explain why the nasturtium is associated with victory. Linnaeus named the plant *tropaeolum* because he thought the helmet-shaped flowers resembled the trophies of battlefield victory. Also, the first Europeans to discover nasturtiums in Mexico and South America were conquistadors, thus the plant came to symbolize conquest.

Inspirational Message: Let even the humblest of flowers remind you that the greatest victories you experience may be the small ones no one else ever sees. Conquering those inner voices of self-doubt is the first step forward in your personal growth.

PANSY
Viola tricolor

Symbolism: Sweet Thoughts

"Pray you love, remember. And there are pansies, that's for thoughts."

— Unknown

According to legend, pansies were originally white but were later colored purple by Cupid. Even with its velvety purple petals, the modest pansy does not demand attention; it simply asks to be kept in your thoughts. In fact, the name pansy comes from the French word *pensées,* which means 'thoughts'. The pansy was a popular flower during the Elizabethan era, and is mentioned often by Shakespeare. It also held great appeal for the Victorians, who saw it as a symbol of tender attachment and sweet remembrances.

Inspirational Message: You are what you think; your life stems from your thoughts. Negative thinking may occasionally enter your mind, but you need not let these thoughts take root. Remember, it is you who decides what fills your mind. Choose healthy, happy thoughts.

PEONY
Paeonia

Symbolism: Prosperity & Compassion

"Prosperity depends more on wanting what you have than on having what you want."

— Unknown

The peony borrows its name from Paeon, the legendary physician to the gods at Mount Olympus. In ancient China, the handsome flower was designated the "King of Flowers". Throughout the world, the sweet-scented flower is considered an omen of good fortune, health and longevity, and prosperity. Some peony plants are said to live for as long as one hundred years. The generous flowers are also associated with fairy mischief as well as compassion.

Inspirational Message: Happiness is not found in pursuing the things we want. It is the joy we find in appreciating what we have in our lives and sharing it with others.

PHLOX
Phlox paniculata

Symbolism: Unanimity & Harmony

"He who lives in harmony with himself lives in harmony with the universe."

— Marcus Aurelius

From the Greek word for 'flame', the phlox flower has been cherished since ancient times. Pliny the Elder included a description of phlox in his encyclopedia of agriculture. Phlox are indigenous to North America and have long been utilized by Native Americans for decoration, cooking and herbal medicine. Europeans were introduced to phlox in 1725 at the Chelsea Botanic Gardens, where people were immediately taken with its charm and delightful fragrance. Because of the close clusters of its many flowerets, the phlox came to symbolize unanimity and harmony.

Inspirational Message: One single flower does not make a bouquet. One voice alone cannot create harmony. It's amazing what you can accomplish when you work in unity, combining the flames of your own passion with others' energy and talents.

PRIMROSE
Primula

Symbolism: Youthful Love

*"If I had a single flower for every time
I think of you, I could walk forever
in my garden."*

— Claudia Adrienne Grandi

Primrose is the sacred flower of Freya, the Norse goddess of love. Its Latin name *primula* means 'first rose of spring' and it is also the flower of first love. In the Secret Language of Flowers, the yellow primrose conveys the message between young lovers "I can't live without you." The purple primrose represents confidence. Through the ages, brightly colored primroses have inspired poets including Shakespeare, Burns, Milton and Wordsworth.

Inspirational Message: When we are young we are willing to take chances for love. As we go through life, we should remember that youthful confidence and exuberance in all we do. Always keep your heart open. Love is all around.

PINK ROSE
Rosa centifolia

Symbolism: Grace & Sweetness

"The pursuit of perfection, then, is the pursuit of sweetness and light."

— Matthew Arnold

There are 40,000-year-old fossil records indicating that the very first wild roses were pink ones. The first cultivated roses were also of pink color. It is known that pink roses were grown in the Chinese Imperial Gardens 5000 years ago. Some of the earliest known artworks depict pink roses. During the Victorian age, dainty pink roses were so popular they inspired decorative wallpaper, stationary, jewelry and many other fashionable items. When pink roses were given or displayed they conveyed gentle sentiments such as grace, admiration, kindness and sweet thoughts.

Inspirational Message: Greet life with grace, even when situations are challenging. Let pink roses be a gentle reminder that in order to have sweet dreams at night, you need to get in the habit of thinking sweet thoughts each day.

RED ROSE
Rosa indica cruenta

Symbolism: Hidden Secrets

*"Three things cannot be long hidden;
the sun, the moon and the truth."*

— Buddha

Red roses have been treasured and imbued with deep meaning throughout history. The floors of Cleopatra's palace were carpeted with red rose petals. The red rose came to be associated with secrets when, in Greek mythology, a rose was given by Eros to Harpocrates, the god of silence. In ancient Roman times and throughout the Middle Ages, red roses hung above the tables were a signal that the words spoken *subrosa* (beneath the roses) would be kept strictly secret. The rose is often used to signify secret religious and spiritual rituals. In the Secret Language of Flowers, the number of roses was as significant as the color. A single red rose meant "You are the one." A bouquet of six red roses meant "I want to be yours."

Inspirational Message: Keeping secrets not only keeps others in the dark, but keeps them at a distance. Always speak your truth even when you think it may hurt. It's better to make someone cry with the truth than to make someone smile with a lie.

WHITE ROSE
Bengale thé hyménée

Symbolism: New Start & Wisdom

"Knowing yourself is the beginning of all wisdom."

— Aristotle

The white rose is the Eastern equivalent of the lotus flower, and similarly denotes the wisdom of enlightenment. One of many myths surrounding the white rose is the story of its first creation. When Aphrodite, the Goddess of Love, rose up from the ocean the sea foam formed roses in her honor. In the Victorian Language of Flowers the white rose held the promise of a new beginning, especially in romantic matters.

Inspirational Message: The petals of the rose are like a spiral. The wisdom you have learned along the way keeps circling back to you, lifting you up to new heights. Even the pain of life's thorny lessons are signs that you have grown and are now prepared for a fresh, new beginning.

YELLOW ROSE
Rosa sulfurea

Symbolism: Enthusiasm & Friendship

*"A single rose can be my garden...
a single friend my world."*

— Leo Buscaglia

Yellow roses were discovered in the Middle East around the time of the 18th century. Europeans fell instantly in love with the cheery yellow roses when they were imported from Afghanistan and Asia. Dutch and French botanists started experimenting with the tender, yellow roses to make them more fragrant and better adapted for Europe's colder climate. In Victorian times, the yellow rose was sometimes associated with jealousy, as it had been during the Renaissance. But it later came to symbolize enthusiasm, joy and friendship. When yellow and red roses are combined in a bouquet, it conveys joviality and happiness.

Inspirational Message: The garden of friendship is like any garden, the more you tend to it, the healthier it is and the more beautiful it becomes. And like flowers, the strength of friendship should not be judged on how long it lasts, but on how much joy it brings to your life.

SACRED LOTUS
Nymphaea caerulea

Symbolism: Enlightenment

"No mud, no lotus."

— Thich Nhat Hanh

The lotus flower grows up out of the mud, yet each day as the petals unfurl and shed the droplets of water, the flower emerges perfectly pristine. For this reason, the lotus symbolizes purity and spiritual transformation. With its flower so distant from its roots below the water, the lotus also represents detachment, a necessary step for spiritual enlightenment. The golden center of the lotus is rarely shown in Zen artwork since it represents the elusive perfection of wisdom. The Egyptian sun god Ra is often depicted with a blue lotus. Because of this association with the sun, the lotus signifies rebirth.

Inspirational Message: Honor all the experiences that have brought you to this place on your path of spiritual growth but let go of the things that no longer serve you.

SNAPDRAGON
Antirrhinum

Symbolism: Graciousness & Benevolence

"No act of kindness, no matter how small, is ever wasted."

— Aesop

Snapdragons were first discovered growing wild in Italy and Spain. In Victorian England, the snapdragon communicated grace and benevolence. If a gentleman gave a lady a bouquet containing snapdragons, it was a compliment to her character and her kindness. The dragon-like blossoms were also believed to have mystical powers that warded off evil and misfortune. Snapdragons were given as housewarming gifts as well as tokens of gratitude for gracious and kind hospitality.

Inspirational Message: It is easy to be kind and gracious with the people we love and care most about. But true grace and benevolence extend to those we do not know and sometimes even to those we may not much like.

SWEET PEA
Lathyrus odoratus

Symbolism: Blissful Pleasure

"Follow your bliss and the universe will open doors where there were only walls."

— Joseph Campbell

The poet Keats may have been the first to call the sweet pea by its common name, which derives from the Greek word *lathyros* for 'pea' or 'pulse', and the Latin word *odoratus* meaning 'fragrant'. Sweet peas of many colors provided an important element in Edwardian potpourris and wedding bouquets as a symbol of bliss. The Victorians were fond of the flower's sweet fragrance as well as its charming butterfly shape. After an enjoyable visit, a bunch of sweet peas was customarily given as a gift to say "Thank you for a lovely time."

Inspirational Message: Invite 'spirit' into your life by simply allowing yourself to be inspired. Spend your energy on your creative passions and you will find your bliss.

SWEET WILLIAM
Dianthus barbatus

Symbolism: Gallantry, "Grant me a single smile"

"Sweet William small has form and aspect bright, like that sweet flower that yields great Jove delight."

— Abraham Cowley

Sweet William may have taken its name from the Old English romantic ballad of sweet William the gallant sailor who pledged his faithful love to Black-eyed Susan. These two wildflowers (*dianthus barbatus* and *rudbeckia*) are often found together, always blooming at the same time. Others believe the flower's moniker was actually inspired by William Shakespeare. To Victorians, the fragrant flower carried the message to their recipient "Grant me a single smile." The tiny tufts of sweet william flowers invite you to come closer, and allow yourself to fall under their spell, as you gaze into their 'eyes'.

Inspirational Message: The most attractive thing you can put on each day is your smile. Your smile will attract more positive energy from others around you. Be the reason someone smiles today.

TRUMPET GENTIAN
Gentiana acaulis

Symbolism: Power & Healing

"To get what you love you first have to be patient with what you have."

—Unknown

The gentian flower takes its name from Gentius, the King of Illyria. According to legend, Hungary was suffering the ravages of a long, devastating plague. In desperation, the king shot an arrow into the air hoping it would guide him to a cure for his ailing subjects. The arrow landed in the heart of the gentian plant, which did indeed provide a cure for the plague. Today, the gentian plant, which grows in alpine mountain areas, is still valued for its medicinal properties as well as its attractiveness. It takes several years for the plants to reach maturity, thus the small but sturdy flower is associated with the extended process of healing.

Inspirational Message: In your desire to heal and grow, summon your strength, not through will, but in patient acceptance of the process that is required to bring true recovery.

TUBEROSE
Polianthes tuberosa

Symbolism: Dangerous Pleasure

"The secret of reaping the greatest fruitfulness and the greatest enjoyment from life is to live dangerously."

— Friedrich Nietzsche

When the tuberose was first brought to Europe from South America and Asia in the 17th century, its name caused considerable confusion, though it simply means a "flower that grows from a tuber, or bulb." The exotic tuberose caused an even bigger stir for its provocative fragrance and its voluptuous appearance that was considered ostentatious. Marie Antoinette commanded her perfumers to create an alluring scent from the flower exclusively for her. In 19th century Russia, the flower was forbidden to anyone outside of the Imperial Court. In Malaysia the tuberose is known as "the mistress of the night".

Inspirational Message: There are times to be restrained and there are moments when your wild, sensual side yearns to be expressed. If you never take risks and allow yourself a few "dangerous pleasures" you will never discover your own true colors.

TULIP
Tulipa

Symbolism: Friendship & Gratitude

"Let us be grateful for the people who make us happy; they are the charming gardeners who make our souls blossom."

— Marcel Proust

First cultivated by the Persians and Turks at the time of the Ottoman Empire, tulips were brought to Vienna by foreign ambassadors. The stories of the "Tulip mania" that swept through Europe beginning in the 17th century are familiar to most gardeners. In the eastern Language of Flowers, red tulips were an emblem of the flames of passion. Later, when tulips became more common in Europe, various colors developed different meanings; white signals purity, yellow means friendship and sunshine, variegated says "You have beautiful eyes", pink means affection and gratitude.

Inspirational Message: Share your burdens with friends and they become lighter. When you share your joys, they multiply and spread. Be grateful for true friends who are there for both the laughter and the tears.

VENICE MALLOW
Hibiscus trionum

Symbolism: Delicate, Fleeting Beauty

"When life is not coming up roses, look to the weeds and find the beauty hidden within them."

— L.F. Young

Members of the hibiscus family, mallow plants were greatly valued for their medicinal, healing properties by Ancient Romans, Arabic physicians, and Chinese herbalists. Pliny said: *"Whosoever shall take a spoonful of the Mallows shall that day be free from all diseases that may come to him."* In North America, Venice mallow is such a ubiquitous wildflower that it is considered by some to be an invasive weed. Yet its beauty nonetheless captivates with its shimmery purple eye in the center of its translucent ivory petals. The luminous flower only blooms for an hour each day, thus it is also known as the "flower-of-the-hour." To the Victorians, the Venice mallow signified 'delicate, fleeting beauty'.

Inspirational Message: Your eyes are capable of seeing beauty in the most commonplace things. Your tender nature appreciates those fleeting moments that make your heart flutter.

VIOLET
Viola sororia

Symbolism: Faithfulness & Modesty

"Modesty is a shining light that prepares the mind to receive knowledge and the heart for truth."

— Madam Guizot

Throughout the ages, there has been a perennial fondness for the diminutive violet. According to botanical lore, the violet was nicknamed the "Flower of Modesty" because it hides its delicate petals close to the ground beneath the heart-shaped leaves. In ancient Greek mythology, the flower symbolized the modesty of Artemis and the loyalty of her companions. The violet was often used in religious art to signify humility and purity. The violet is said to have blossomed when the archangel Gabriel announced to Mary that she would bear the son of God. Popular during the Renaissance and Victorian periods, the violet has always had positive associations with charming shyness and demure modesty.

Inspirational Message: While there's no need to hide your light beneath a bushel, it's not always necessary to clamor for attention. Sometimes the quietest voice with a modest message is the one that holds the greatest wisdom.

READING WITH THE BOTANICAL INSPIRATIONS CARDS

The Botanical Inspirations cards can be used for daily inspiration and affirmations. As you start your day, select a card from the deck. Either close your eyes and pick one at random, or look through the cards and let a flower pick you. As you read the message think about how these lessons may apply to you. As you go through your day, try to remember the flower's symbolic meaning. You might even carry the card with you to find calm and encouragement during challenging moments. Or share a card with a friend.

THREE-CARD FLEUR DE LIS READING

The Fleur de Lis has several traditional meanings. The most common interpretations are: Faith/Wisdom/Valor or Perfection/Light/Life. You can use the

Fleur de Lis pattern for a three-card reading to bring needed insight to a personal issue you might be currently struggling with. The question may relate to romance, family, finances, job matters or any sphere of your life. After formulating a question in your mind, select three cards and place them face up as shown below.

Card 1 signifies the situation as it is.

Card 2 indicates the course of action to be taken to resolve the situation.

Card 3 projects the improved outcome of the situation.

Sample reading: Kate is having problems at work. She feels her efforts are going unappreciated.

```
              ASTER

CLEMATIS              DAHLIA
```

Card 1—Clematis. This card relates to your intelligence. You are bringing great ideas to the workplace. You may feel they are not being appreciated, but perhaps they actually are.

Card 2—Aster. This flower suggests that you need to continue to be patient and have faith that things will turn out for the best.

Card 3—Dahlia. The Dahlia reminds you that the dignity you have shown is going to serve your long-term interests.

Message: Like the Clematis, keep reaching toward your goals. Your patience and dignity will be rewarded. You will soon have your moment to shine.

A three-card reading can also be done to explore past, present, and future perspectives.

	2	
	Present	
1		**3**
Past		*Future*

Sample reading: Meghan has been in a long distance relationship with Daniel. She is wondering where it will go from here.

[PRIMROSE] [DAFFODIL] [HONEY-SUCKLE]

Card 1—Past. The Primrose symbolizes youthful love. When this relationship began you were full of hope and willing to take chances.

Card 2—Present. Daffodil means new beginnings for you. Your relationship is changing and evolving for the better.

Card 3—Future. The Honeysuckle vine indicates that your relationship will continue to thrive and blossom. You can expect happiness that grows out of deep affection, and ultimately you will enjoy domestic bliss.

For our complete line of playing cards, gift items, meditation cards, oracle and tarot decks, and other inspirational products please visit our website:

www.usgamesinc.com

U.S. Games Systems, Inc.
179 Ludlow Street
Stamford, CT 06902 USA
203-353-8400
Order Desk 800-544-2637
FAX 203-353-8431